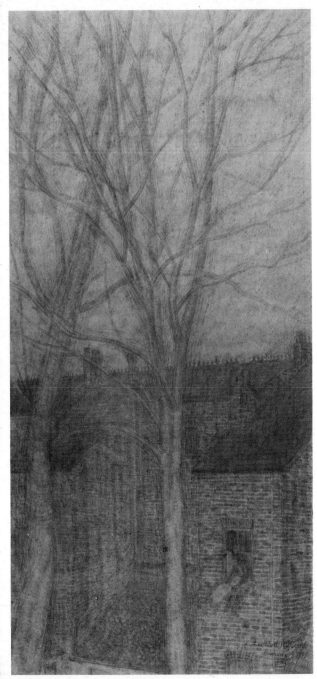

66 Leonard McComb *Gardens, South London* 1977

more
than
a
glance

an Arts Council exhibition
showing at

Sheffield
Graves Art Gallery
4 October to 2 November 1980

Cheltenham
Cheltenham Art Gallery and Museum
8 November to 6 December 1980

Swansea
Glynn Vivian Art Gallery and Museum
13 December to 24 January 1981

Southampton
Southampton Art Gallery
7 February to 8 March 1981

Wakefield
The Elizabethan Exhibition Gallery
14 March to 19 April 1981

Preface

Joanna Drew
Director of Art

More than a Glance is a slightly unusual exhibition dealing neither with a limited historical period nor with a movement or theme which can be easily labelled. Instead the exhibition is intended to explore a particular approach and attitude to the making of art, shared by artists widely separated by time and by the apparent nature of their work. Nearly three and a half centuries are covered by the birth-dates of the artists included and this span also reflects the range of material, from Rembrandt's etchings to Emma Park's abstract constructions.

We are grateful to Andrew Walton, himself a painter, who, with my colleague Michael Harrison, has undertaken the selection of the exhibition and written this catalogue. We are also grateful to the museums, artists, and private collectors who have most generously lent their works.

Acknowledgement

Andrew Walton
Michael Harrison

The lenders' list in the back of this catalogue gives some indication of our itinerary in the formation of this exhibition. In many museums and galleries we have benefited from the patience and goodwill of curators who have allowed us to search their collections and provided us with much help and information. We thank them most sincerely and hope that this catalogue and the exhibition itself will, at last, explain our intentions.

Introduction

Andrew Walton
Michael Harrison

Through talking, drawing and visiting exhibitions together, we realised that there were common qualities that interested us in pictures. In conversations we made links between pictures and wondered whether an exhibition could be formed which would explore and allow further understanding of this ill-defined family of qualities.

We decided to attempt some clarification by listing the artists we responded to most from a purely personal point of view. From these lists there emerged themes that connected the artists which varied from similarities of structure to shared attitudes to subject. Never arriving at a concise definition of our aims, we have nearly always been able to know if an artist's work was within the approximate range of our idea while newly seen work has adapted and enriched the exhibition's scope.

Certain artists formed the central core of the exhibition from the outset. Our excitement at finding the etchings and then the paintings of Cornelis Bega, hitherto unknown to us, was in fact our starting point. So we hunted through the collections of various museums for works by these key artists – Bega, Rembrandt, Cotman, Gilman, Morandi and some others – and in the course of our search came across other works which seemed to be part of what we were considering. The Mistress of Ince Castle was a revelation and found by complete chance while browsing in the Whitworth Art Gallery's collection.

Our main guide has not been theme or theory but the striking of a bell when something seemed right. Our 'theme', if one has emerged, is open-ended and we have made no attempt at a comprehensive survey. However this catalogue will give a partial indication of the attitudes we have had to the works and reflect something of those characteristics which might link them and make their gathering a useful occasion. It is the work itself, though, which is most eloquent and convincing about what seem to be common qualities of a truthful approach to image-making.

'*There is room enough for a natural painture. The great vice of the present day is* bravura, *an attempt to do something beyond the truth. Fashion always had, and will have its day; but truth in all things only will last, and can only have claims on posterity*.'
John Constable writing to John Dunthorne in 1802.

Constable's talk of 'the moral feeling of art' became slightly difficult to take after the moralizing of the Victorian years which followed his death. But his stand against heroic subject-matter and his delight in what actually exists, in ordinary and near-to-hand things, is very much to modern taste – a taste we share and one that can be traced through most of this show.

At one time we had thought of including objects – a Shaker chair, a pot – objects which achieve that air of particularity through being functional and through each part bearing witness to conscious conception and careful making. It's there to be found in the structure of a dovecot or in the solutions found by the engineer-architects of the great 19th century railway stations. In this exhibition the construction of Brunel's *Great Eastern* is celebrated in Howlett's photographs, and Cotman is attracted to man's creation, be it Romanesque architecture or the makeshift structure of a lime-kiln.

We share both in the artist's joy and in the same qualities which make up the pictures themselves. Again we are engaging with another's activity. Our engagement as a viewer is with the artist's act of creation. Our satisfaction is with the correspondence between his experience and ours, and the succinct rightness of the language he has used – a quality we take for granted in poetry but not so readily in painting. And so the language of the picture, the elements of construction, needs to be evident to provide us with footholds back and forth through the process of its creation. The artist is reticent and economical of means, but is present and not wholly self-denying.

His roles are various, sometimes that of objective reporter, sometimes pursuing a more personal path. The illustrators of Diderot's *Encyclopédie*, the draughtsman of the Tower of London and the war artists of this century had a job to do, clearly to set out information about their subjects. Other artists were free to choose their subjects but they too imposed their own restrictions or, more positively, found a sufficient wealth to explore within familiar and seemingly small areas. Morandi's repertoire of still-life objects was cast and recast in different formations, like Bega's peasants and the sparce furnishings of the places they inhabited. Series and sequences of works occur allowing us to engage further with the artist's methods and intentions. We can follow Hollar across Islington and piece together his landscape but we can also follow the variations of Gwen John's church studies – the same motif seeking its resolution in colour and tone.

There is a quietness to all the works. Colour tends to be subservient to tone and where there is activity, in a Roberts war drawing or in a Bega tavern scene, order creates stillness. Where human beings appear they are preoccupied in work, in reading or writing, in sitting for the artist or simply in their own thoughts: they are seen with respect and tenderness, with lives of their own. Where there is no human being his presence, past or future, is implied. There is a sense of time, of the moment depicted – of time having been spent by the artist and, now, time being spent by us in looking at the work.

A narrative picture does not include us in its action – the story is complete without us and we can merely observe – but our minds can enter and expand into these works. Their particularity and completeness does not constrict us, and our imaginations can live in their spaces, sense their smells and sounds. They can become part of our world as we contemplate them and become part of theirs.

9 Cornelis Bega *The old hostess c.* 1660

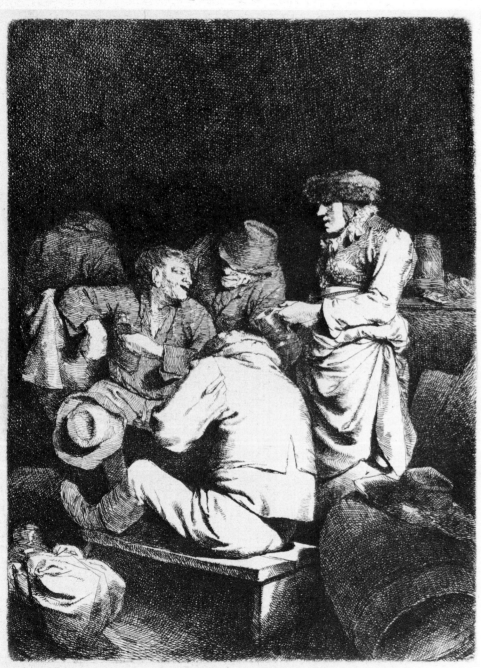

In a Roberts drawing or a Bega etching of a group of people, involved in some job or activity, we are there with the people in the same place, watching what they do. In no sense are they a frozen group or arrangement whose slightest move will destroy the picture. Yet as pictures they are highly ordered and artificially structured. The ordering reveals the subject, makes clear the complexity of all that happens in a scene, and suggests life, and more activity, exchanges, nudges, exclamations. The people will presently go their individual ways. They are not there for the picture.

91 William Roberts *Love song in a bar* 1923

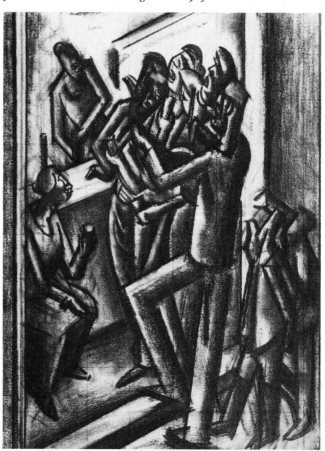

A quality of William Roberts' work is his recording of people going about their business. Nobody is posed in *Brigade Headquarters*, each is absorbed, seen at a moment of action. Hine's picture is the same, as people hurry home. Crisp moments. As pictorial structures they are intelligent and thought-out.

43 Lewis Hine *Massachusetts Mill* 1913
88 William Roberts *Brigade Headquarters, Signallers and Linesmen* 1918

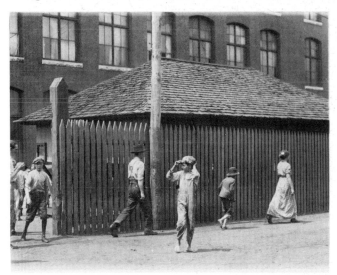

92 William Roberts *The Café*

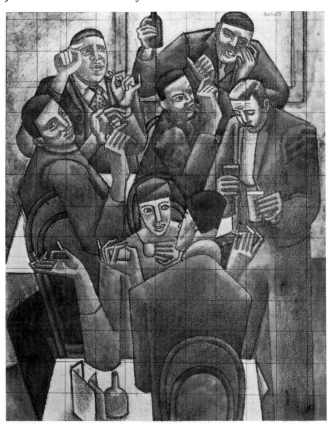

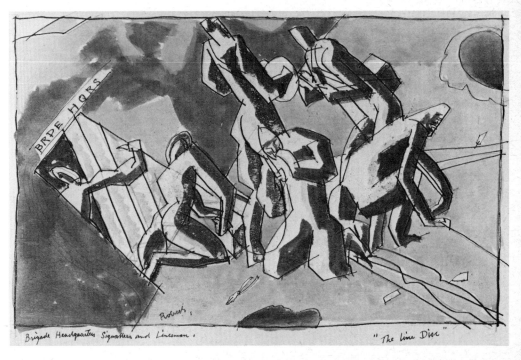

67 Kenneth Martin *Metamorphosis 1c–1oc* 1974

'*One makes an object out of sequences of events.*'
Kenneth Martin, *Chance and Order*, published in
One, October 1973.

Two apparently opposite poles – Kenneth Martin and the Mistress of Ince Castle. What happens? A careful ordering of parts – highly selective. These are not any old lines, sequences or places. Each image is constructed, a particularity achieved. Time is involved in the order and overlapping of lines in Martin's drawings. In working through the sequence we become aware of structure, time and even temperament, of the pace at which they can be understood.

And with the Mistress a similar immediacy of first sight. They are complete, present, yet restrained and evenly paced. Each slowly gives up its qualities with a steady gaze. We are outside them certainly, held back by the cliffs on either side, or the wall overleaf. Yet we can easily move across the spaces, finding places, objects, trees. And each has light, obviously of a kind conventionally applied yet alive, real, illuminating the actuality of a specific time of day. Time exists and its passing allows one to walk across the hills, or to the other side of the buildings to see what is to be viewed from there.

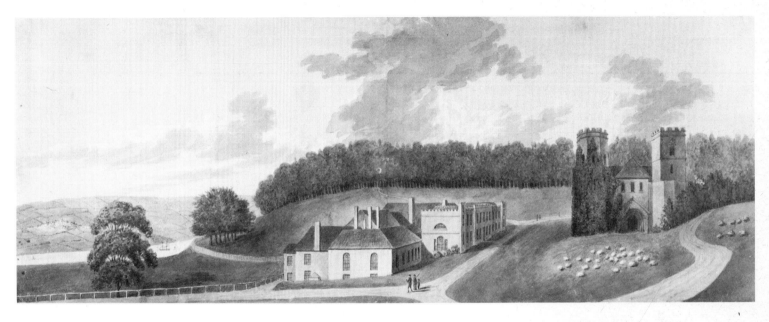

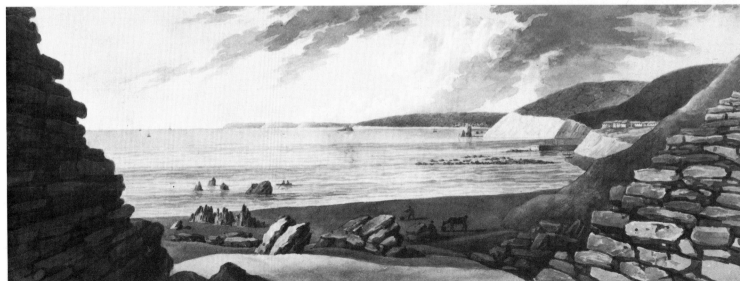

54 The Mistress of Ince Castle *Port Eliot, Cornwall* after 1805

53 The Mistress of Ince Castle *Portrinkle, Landsend* after 1805

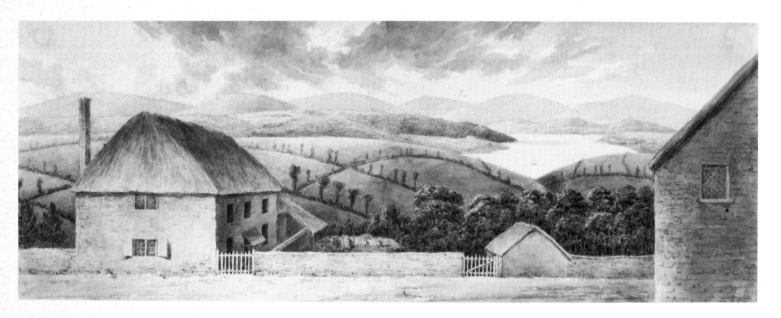

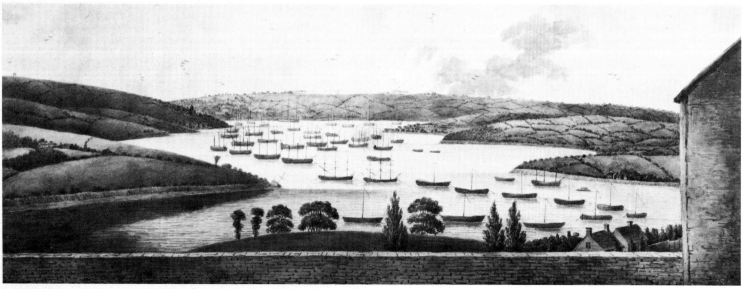

57 The Mistress of Ince Castle *Looking towards Hamoaze from Crafthole* after 1805

58 The Mistress of Ince Castle *View across Plymouth Sound* after 1805

The Mistress of Ince Castle – peaceful, comfortable, yet not nostalgic for they are without sentiment. An honest description, an assembling of facts showing respect and restrained liking for the stone wall, the gate, the sound of sea 200 yards off. The birds are markers for places identified on the backs of the drawings: places thoroughly inhabited by man and known to the artist who lived there. A curiously 20th century view of things in that the pictures are apparently of scenes not chosen and drawn by a professional hand for their saleability. Yet very much of their time.

Ginner painted the view from his window in Hampstead many times, but this time he has taken a pace or two back to allow us into the room, to stand in the place of the artist and share his familiarity with the scales, the inkpot, the table-top.

Ginner had written a manifesto of his aesthetic beliefs published in the *New Age,* 1 January 1914:
'*All great painters by direct intercourse with Nature have extracted from her facts which others have not observed, and interpreted them by methods which are personal and expressive of themselves – Greco, Rembrandt, Millet, Courbet, Cézanne – all the great painters of the world have known that great art can only be created out of continued intercourse with Nature.*'

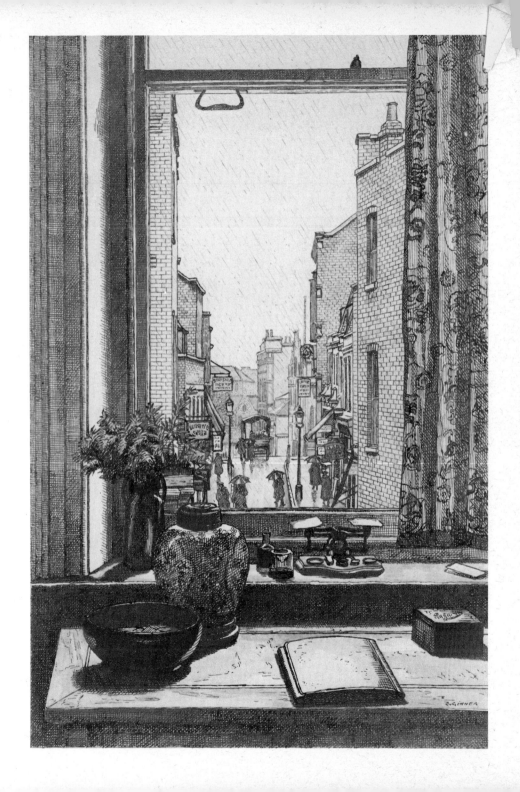

34 Charles Ginner *Flask Walk, rain*

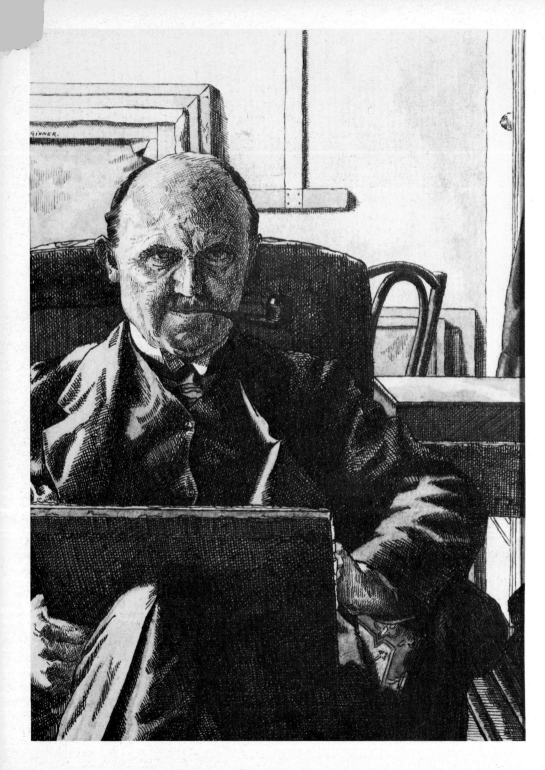

36 Charles Ginner *Self-portrait c.* 1940

32 Harold Gilman *Artist's mother in bed writing c.* 1917

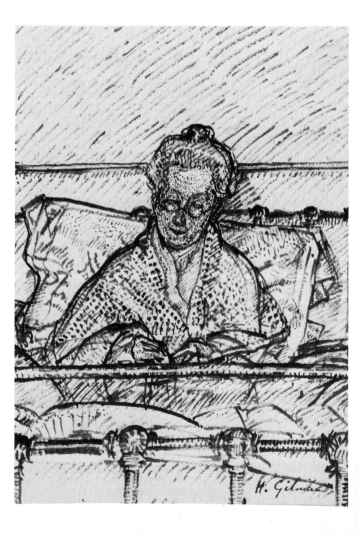

These works have much in common in temperament and composition. The figures are held within frames of furniture – at the base of each something solid, keeping us slightly at bay. Behind, a pyramid of cloth enfolds, catches light, becomes landscape to travel over to the portraits at the summit. Without idealism, each attempts to mould with light a solid head, tenderly and incisively, looked at directly.

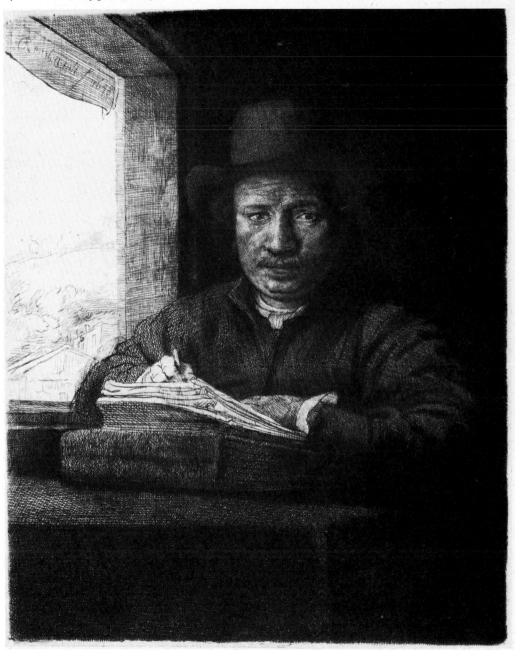

84 Rembrandt *Self-portrait* 1648

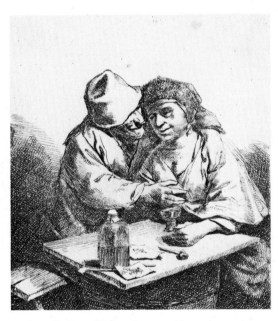

7 Cornelis Bega *The two lovers c.* 1660

49 Wenceslaus Hollar, plates from *Theatrum Mulierum,* first published 1643

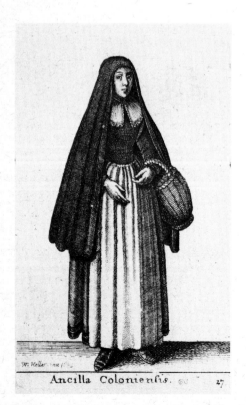 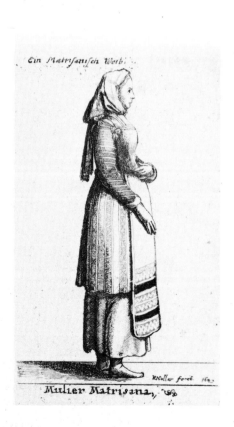 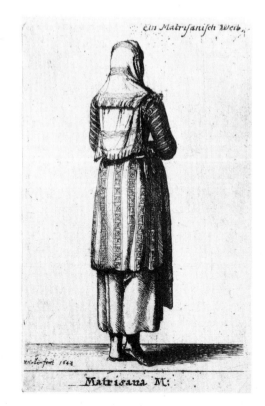 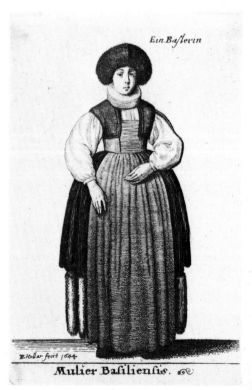

Ancilla Coloniensis.

Mulier Matrisana.

Matrisana M:

Mulier Basiliensis.

Hollar's figures are like small bronze figurines, partially because they lack environment, but there is a clarity of description and a slightly rigid formality reminiscent of medieval sculpture. Drawn 'for the most part in the places themselves from life', they are so much more than mere costume illustration – sympathetic, concentrated images, without theatricality (despite the title of the series). The air is crystal clear.

Hollar's engravings were admired and collected by Rembrandt. John Evelyn wrote in 1662 about the works of *'this very honest, simple, well-meaning man'* *'there is not a more useful or instructive collection to be made'*.

McComb is a sculptor as well as a painter and his sense of form is bound up with the concerns of his drawing. The drawings become sculpture yet have air throughout – air and light that touches the surface of glass, wall, flowers, like a hand moving over the form, feeling the substance.

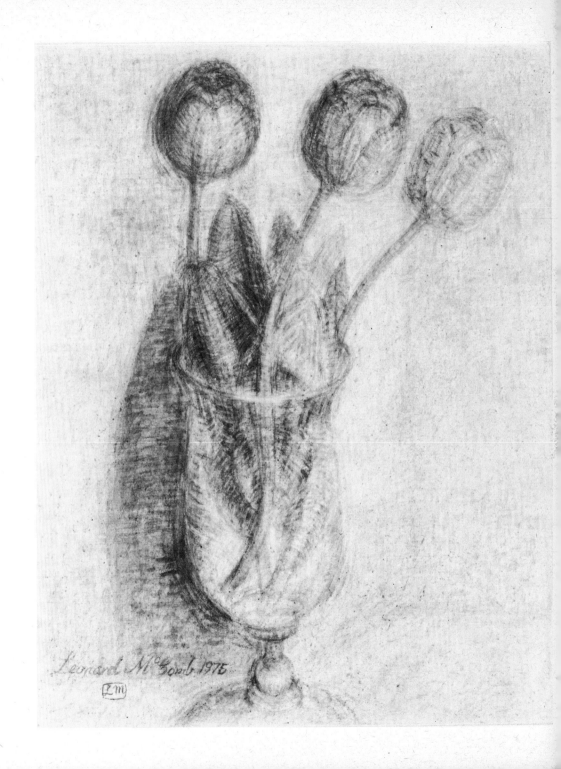

The Constable and Ravilious while both speaking of human activity are deserted except by the artist or us. The Constable is very much as he stood on the mud with the smell of the estuary and sounds of water. He's got hold of the place and felt it – knows it's not about art, about theory or making pictures for drawing-rooms, but about evocation through description. He paces out the space across the picture with wooden posts and creates a distance to the far shore.

Howlett and Ravilious are both playing the role of reporter: Ravilious as a war artist. Howlett is documenting an extraordinary human achievement, the vastness of its physical scale, an enormous act of imagination, difficult for our minds to encompass. The builders of the Great Eastern stop work to face the camera, acknowledging the camera and photographer as the unseen focus of the scene.

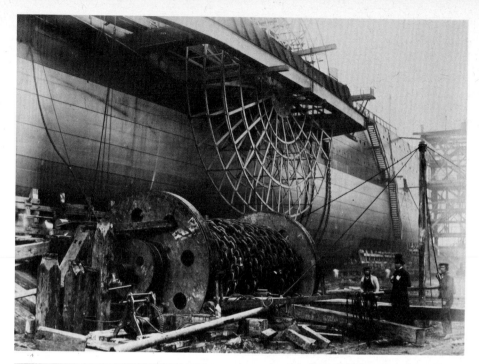

11 John Constable *River scene with vessel: sunset* 1796–9

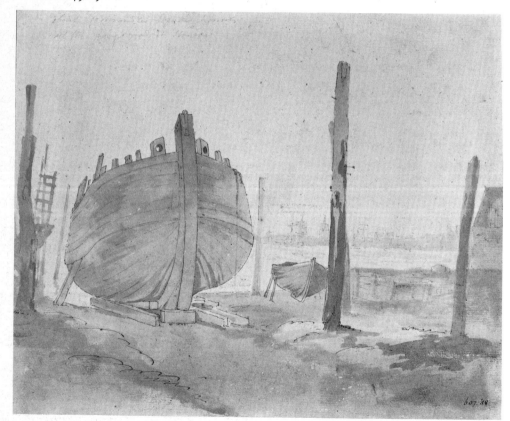

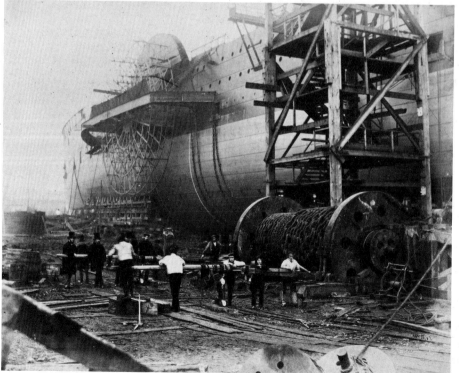

Submarines in dry dock is entirely man made, except for the sky and Ravilious has forged its artificiality into a stage set, pending action, the submarines pointing away from us.

McComb's oranges are brought close, within our grasp, the space behind them confined, the base of their stand cut off. In all these pictures there is description, by light and contour, of rotundity and taut volume.

65 Leonard McComb *Oranges* 1975

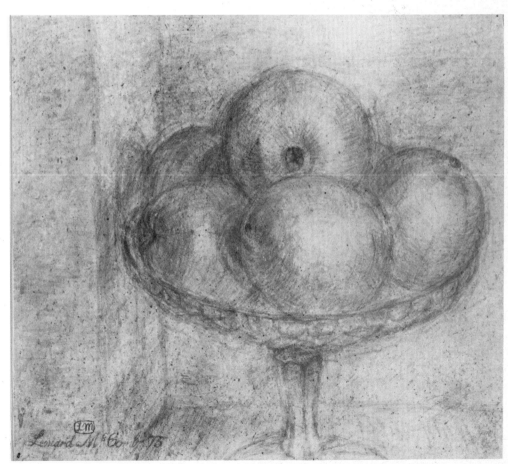

79 Eric Ravilions *Submarines in dry dock* 1940

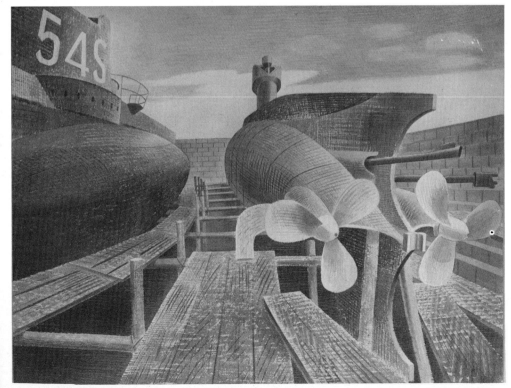

42 Mary Headlam *Jamaica* 1936

Mary Headlam does not record places but is in
them, working with a certainty of method:
almost akin to Morandi's in its consistency
throughout a working life. Her drawing is
descriptive and precise, marks pointing to
surface, direction, distance, density. The light is
emotive, washes the whole. Palmer was of great
importance to her. Sutherland taught her
etching in the late 1920s. Sitting absorbent,
watchfully like a fisherman, her attention is
directed out from one point rather than in onto
one. She senses the mystery of being, of being in
a place, on the surface of the earth, lit from the
sky.

41 Mary Headlam *Mandeville, Jamaica* 1936

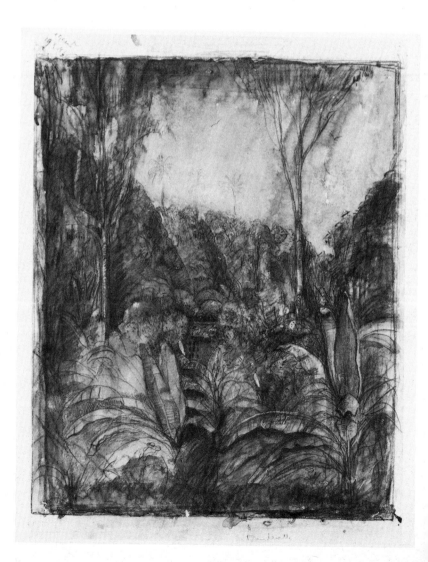

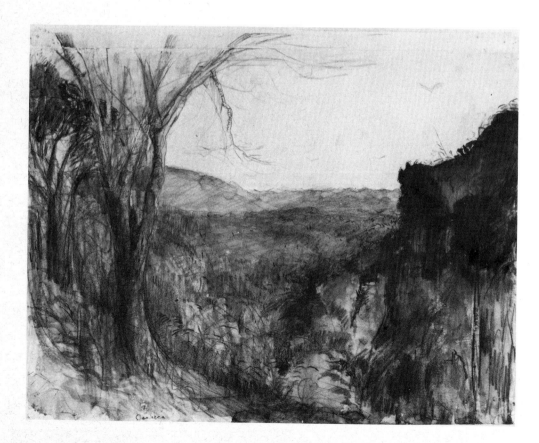

39 Mary Headlam *Chanctonbury Ring, near Steyning, Sussex*

The Palmer is all matter, leaf-mould and brittle sticks underfoot. The substance of ink physically becoming the fabric of trees, enclosing a place.

Samuel Palmer wrote of a visit from William Blake:
'*Nature, Precision, Beauty, – to walk with him in the country was to perceive the soul of beauty through the form of matter*'.

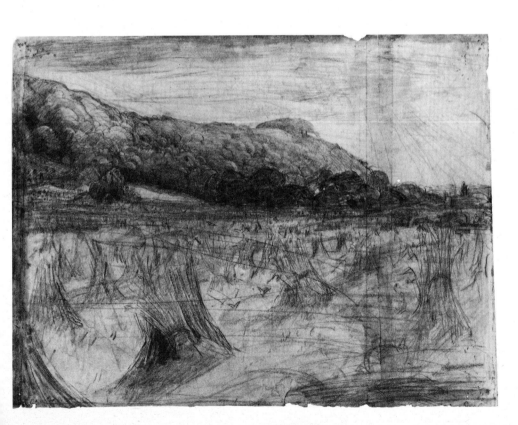

75 Samuel Palmer *Dark trees by a pool*

94 Francis Towne *The head of Lake Geneva from Vevay*

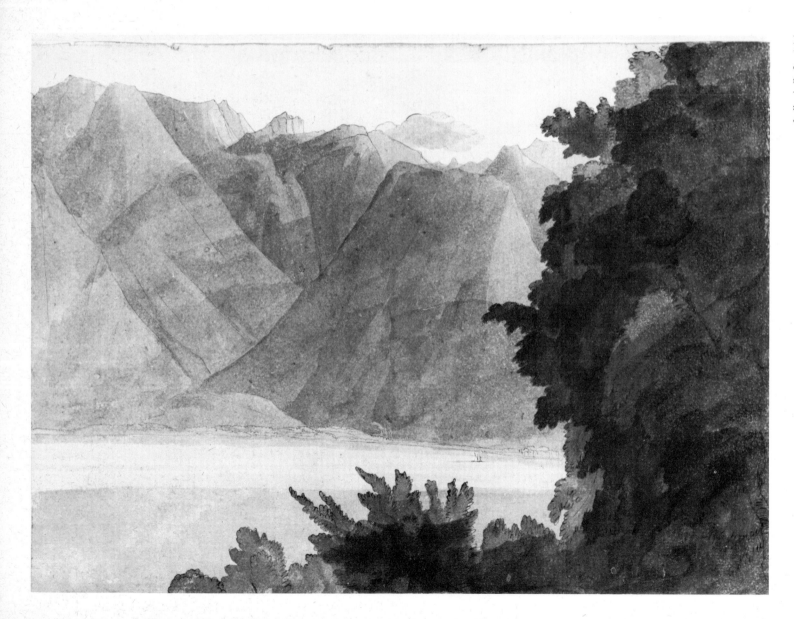

Nature at its most awesome and dramatic, but Towne and Hiroshige have distanced it. Towne covers the mountains in comfortable light, the sun catching the peaks with a lyrical softness which sets the raw danger of such places in another world and brings the experience within our compass.

60 Gwen John *Two Nuns and a woman at prayer*
c. 1925

46 Hiroshige *Shrine at the side of a lake*

No faces, just shapes.incense, overcoats, the echo of a chair creaking. All the light is absorbed, muffled on the way down from the high clerestory windows.

Gwen John wrote: '*A beautiful life is one led, perhaps, in the shadow, but ordered, regular, harmonious*'.

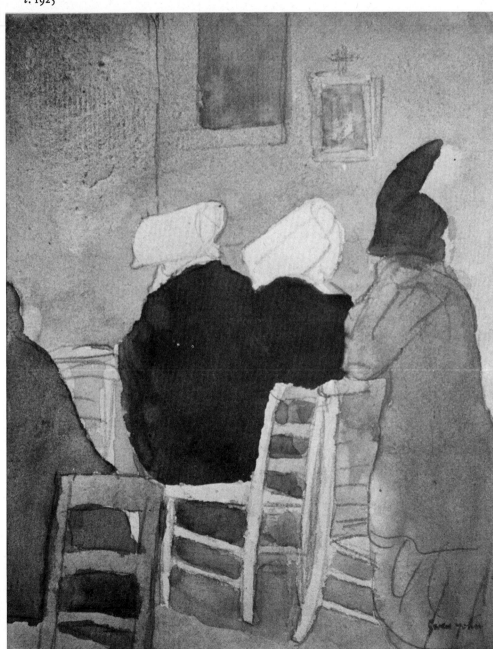

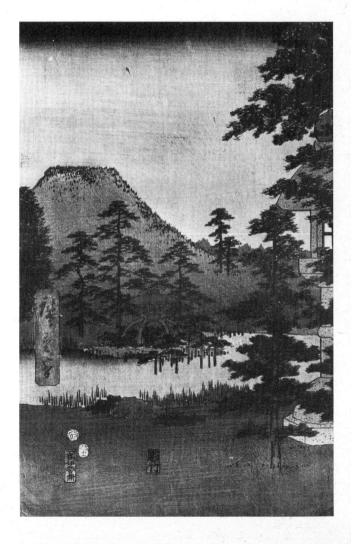

29 Harold Gilman *The eating house c.* 1912

One's eye can rest on each patch of colour in Gilman's *Eating house*, absorb, move on, rest again, sense the shift of space, texture and substance. Each colour almost becomes an edible entity with its own taste. Your eye can't slide around this painting: it is eased over the matter, thoroughly engaging you in the place.

The low light reduces sudden shifts of colour and tone, gives a slowness of pace. Morandi similarly grasped the half light as emotionally enclosing but revealing proportion and space as experiences to be dwelt upon. Gilman studied Velasquez and his tonal delicacy owes much to the 17th century in Spain. It aims at tonal relationships that create an integrated harmonic wholeness.

Morandi wrote:
'*What interests me is to express what is in nature and in the world we see. . . . There is nothing abstract for me, therefore I also believe that there is nothing more surreal, more abstract than the real*'.

73 Giorgio Morandi *Still-life* 1959

70 Giorgio Morandi *Still-life with pine-cone and fragment of vase* 1922

72 Giorgio Morandi *Still-life, bottle and three objects* 1946

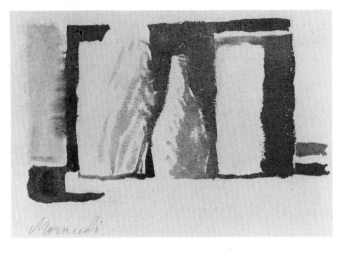

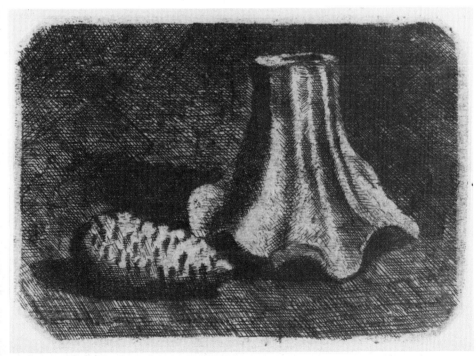

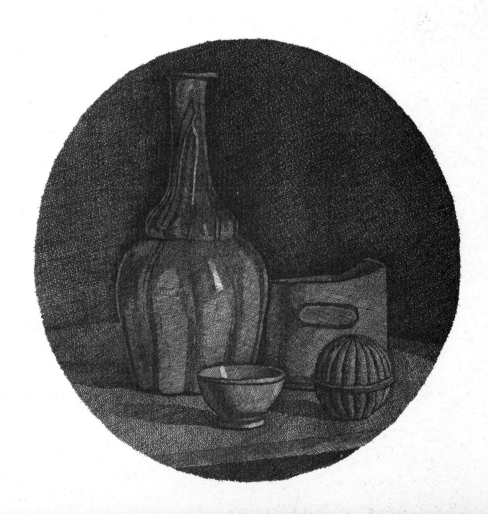

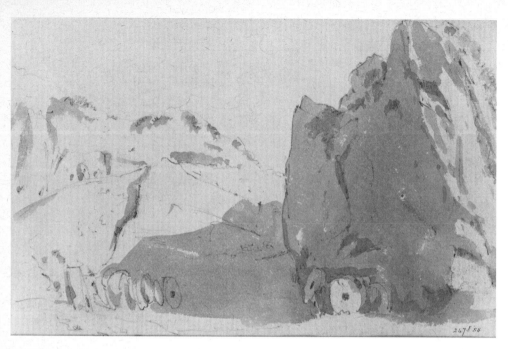

12 John Constable *View in Derbyshire* 1801

Where no person is present, millstones and wheelbarrow offer clues to human activity and human scale.

Hollar etched and engraved his six Islington views in 1665, the year before the Great Fire. They are probably the most intimate and personal landscapes which he made. *Ye Waterhouse* shows old St Paul's in the distance, the tower of St Sepulchre to the right. For *By Islington* (left) Hollar has moved to the West and crossed the far bank. From about that point he turns back to draw the Waterhouse again.

We are exercised to chart Hollar's movements from one viewpoint to the next and to reconstitute the scene into a coherent landscape.

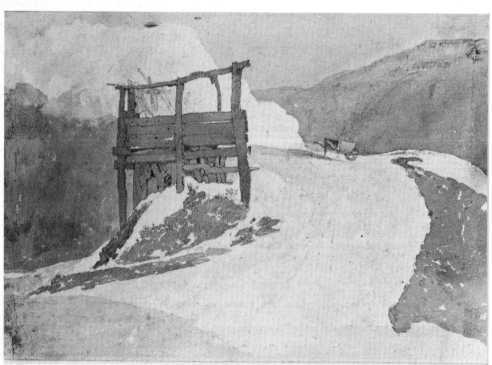

15 John Sell Cotman *Lime-kiln at Cromer*

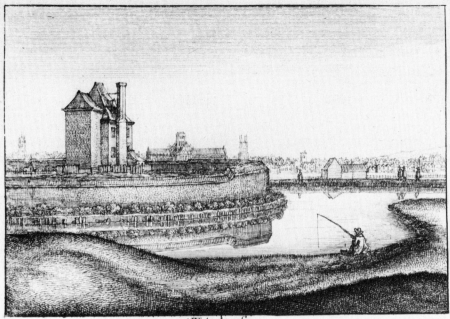

y Waterhoufe

Hollar fecit 1665

By Iflington

W. Hollar delin: et fculp: 1665.

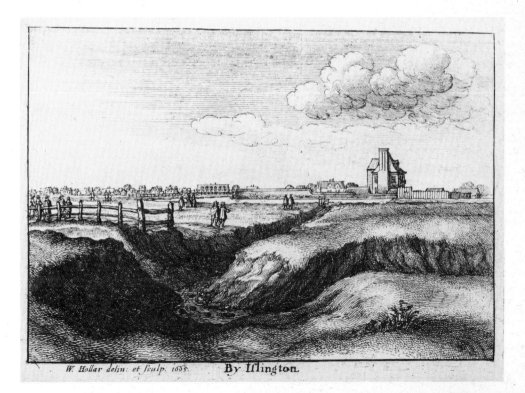

W. Hollar delin: et fculp. 1665.

By Iflington.

There are times when we feel particularly tuned to the quality of the moment. We can identify with Gilman's nurse, the pleasure of sitting in the sun, reading, possibly a light breeze, and some noise, a brief time for oneself. The curtain against the sun somehow evokes the darkened room within. If this were an anecdotal painting, its elements would distract from the subject rather than form our perception.

Gwen John's room is quite bare yet we still sense time and place. The sitter conscious of her task, of the day's warmth, her mind wandering and returning as the light moves around the room.

There is tenderness in all these pictures, quietness but not silence. The size of the Bega etching helps concentrate our attention on the incident.

6 Cornelis Bega *The refused caress* c. 1660

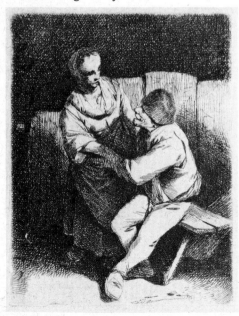

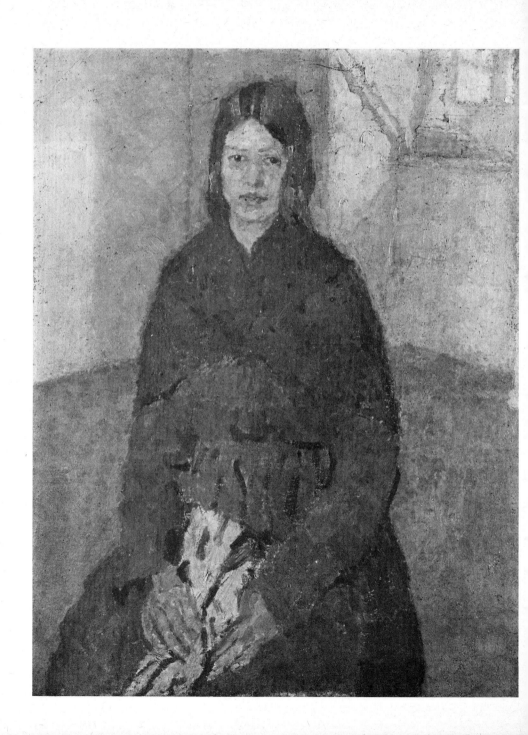

59 Gwen John *Seated girl holding a piece of sewing* 1921–2

83 Rembrandt *Woman reading* 1634

28 Harold Gilman *The Nurse* 1908

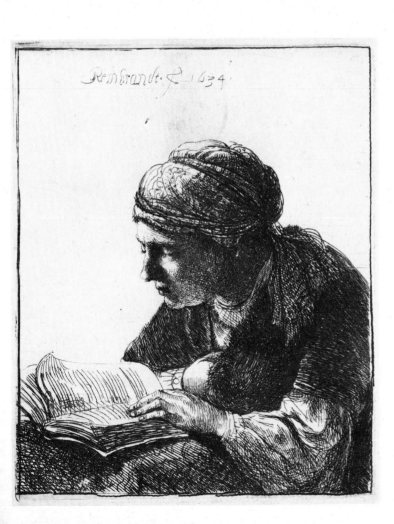

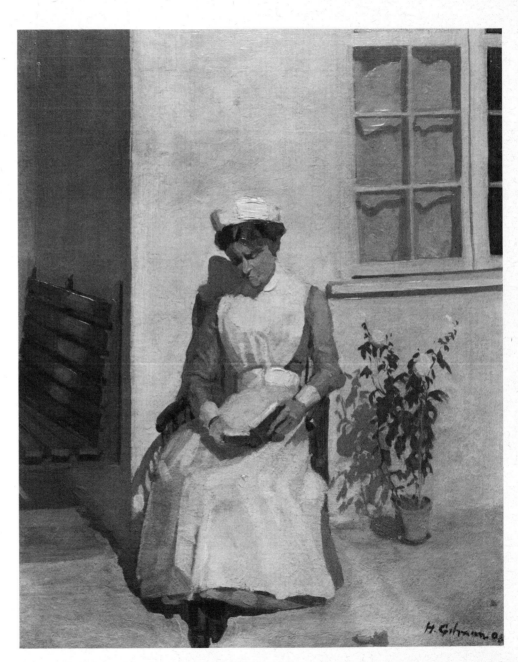

19 John Sell Cotman *Church of Gravelle* 1818

74c F. Nash *Transverse Section of the White Tower*
 1815

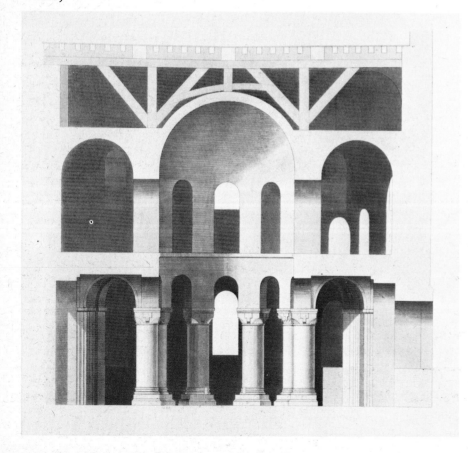

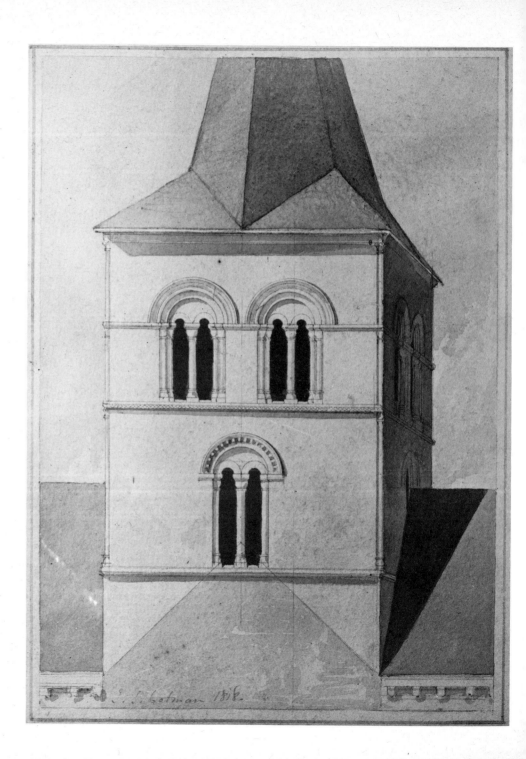

Cotman's monochrome watercolours were to
serve as models for his etchings, providing an
architectural survey of Normandy's churches.

In his work for the Farm Security
Administration, between 1935 and 1938, Walker
Evans took photographs of several church
façades. They are taken straight on. He is not
manipulating his subject to make a good picture
but recording it for its own qualities which he
obviously savoured.

25 Walker Evans *Church, south-eastern US* 1936

20 John Sell Cotman *Church at Pavilly near Rouen* 1818

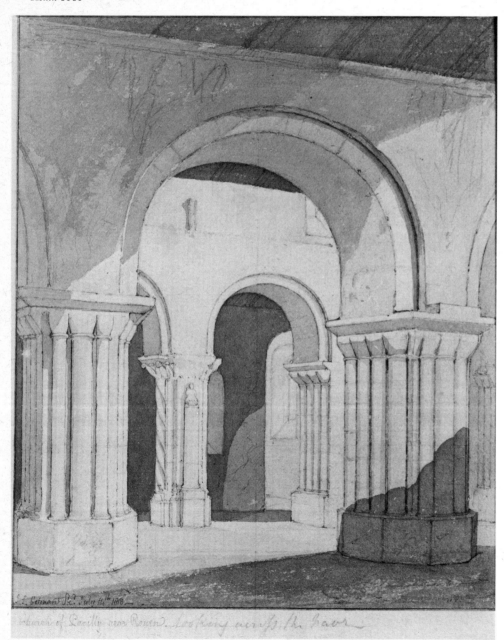

Sometimes its good to have experience stripped down to its elements, to have insights into the parts. Cotman's watercolour of the Church of Pavilly near Rouen is as sparce in its means as the engravings of the White Tower, yet their description through light is so acute that we can inhabit their spaces.

Emma Park's constructions have that same clarity. Her means are apparently stark yet she does not arrive at a statement without feeling. The spaces, openings and intervals seem to be of a family with architecture. We can move through them with eye and mind, informing ourselves of their structure and logic, the process of discovering calmly measuring the passage of time.

Morandi spoke of architecture as '*the correct play, precise and magnificent, of shapes under light*'.

76 Emma Park, four sculptures *Untitled*
December 1978

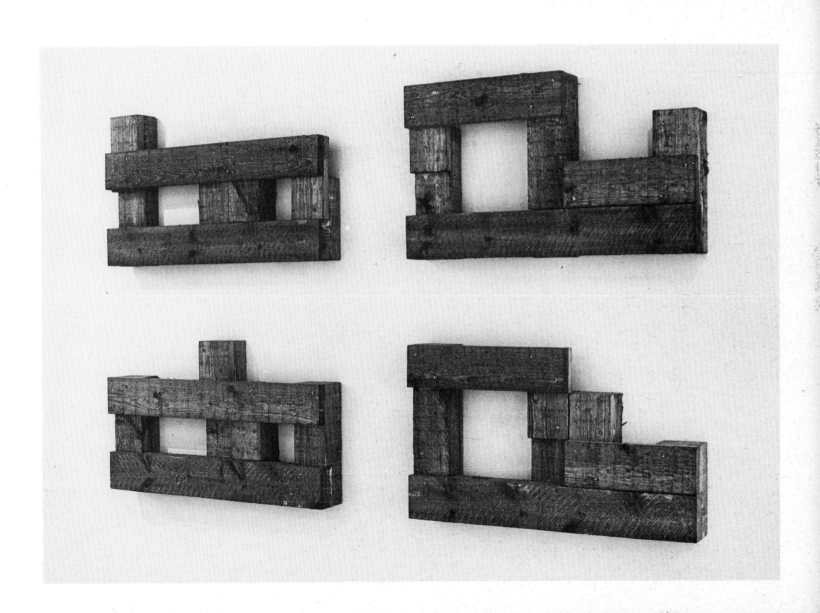

The paintings and etchings by Bega are at first
sight anecdotal scenes of peasant life. Bega's
reputation suffered a decline in the 19th century.
When it came to art, the Victorians' inclination
was to view the lower orders with sentiment.

His people are complex individuals, not the
common 'types' of van Ostade or the Victorian
cottage pictures. Their thoughts are private
though their privacy absorbs us. After the first
impression comes a sense of extreme order and

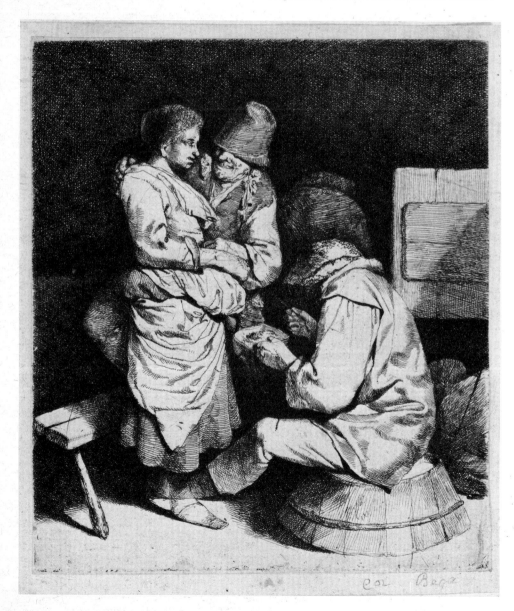

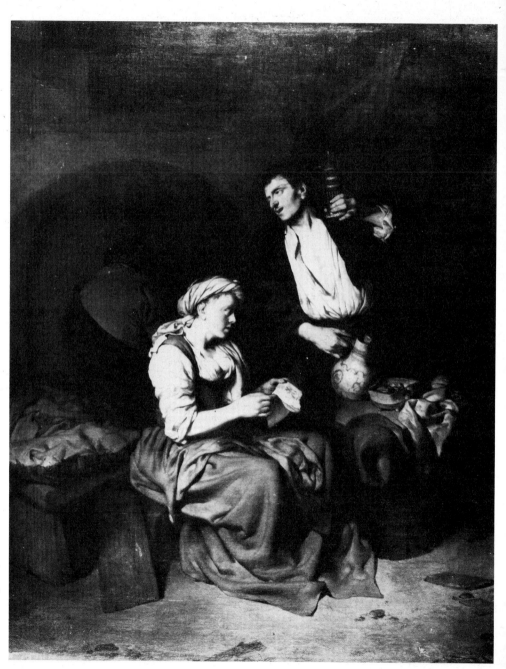

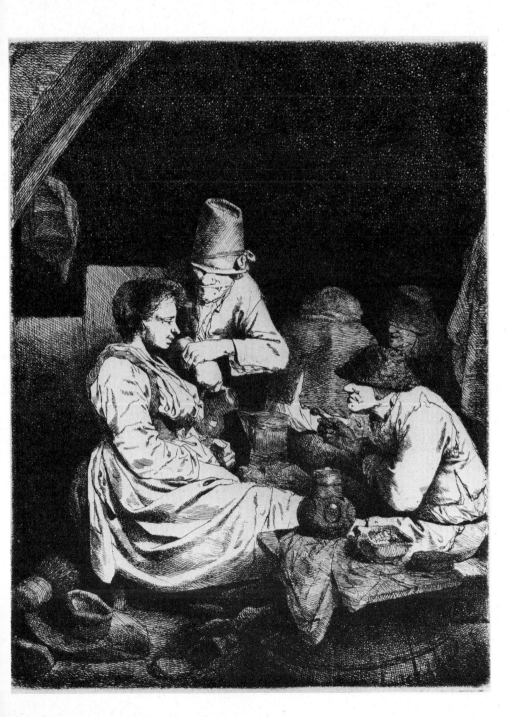

pictorial structuring closer to 20th century developments in Dutch art than to most genre scenes by his contemporaries. Working from one composition to another becomes like the experience of tracing the sequence of Kenneth Martin drawings as Bega plays with permutations of figure groups.

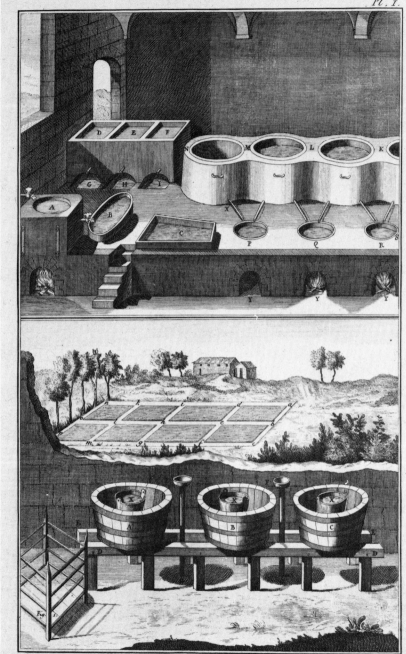

Blanchissage des Toiles.

37c *Linen bleaching,* a plate from Diderot's *Encyclopédie,* published 1751–1772

1 John White Abbott *Near the Friars' Walk, Exeter* 1808

Evelyn Dunbar and Eric Ravilious were commissioned as war artists; Ravilious was posted with the RAF, Dunbar 'commissioned to paint agricultural and other subjects and women's activities'.

The Ravilious is a really clear description of the hollow sound as foot falls on the wood floor. The bed, chair and flying boats all have their separate identities. It's a place which seems familiar perhaps because the chair, the bed, the flimsy shed-like structure are common enough for us to recall them from our own experience – ordinary things to see in a way that reveals rather than transforms. We know how wet a day it is. We also know the time of day in the Dunbar, and the smell.

There are similarities of space and composition in all four scenes: a definite foreground area and a piercing through to landscapes beyond. The White Abbott is particularly rich in its variation of light and space, its open and enclosed spaces – an actual place seen in bright summer sun – complex, with a history of habitation. One might turn a corner and find cabbage-picking or cotton bleaching. It's the same world.

81 Eric Ravilious *R NAS Sickbay, Dundee* 1941

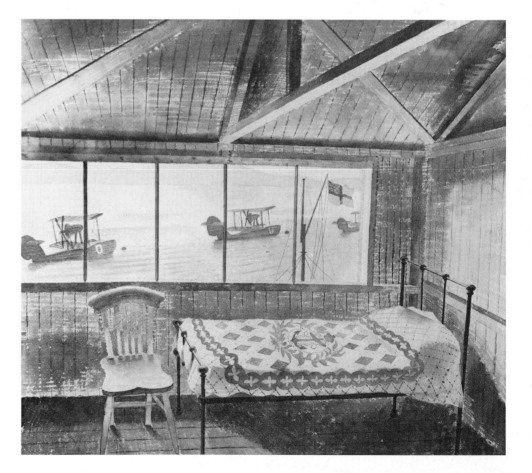

23 Evelyn Dunbar *Cabbage picking, Monmouthshire* 1943

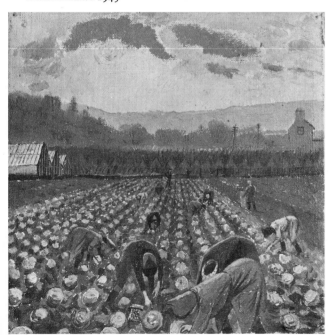

30 Harold Gilman *Letter writing (the artist's mother)* c. 1917

31 Harold Gilman *Artist's mother in bed reading* c. 1917

Model and artist are equally absorbed in their quiet activities, at ease with each other. We can hear the rustle of sheets and shawl as spectacles are adjusted in the course of the afternoon. the scratching of Harold Gilman's reed pen. The smells of an old person's bedroom.

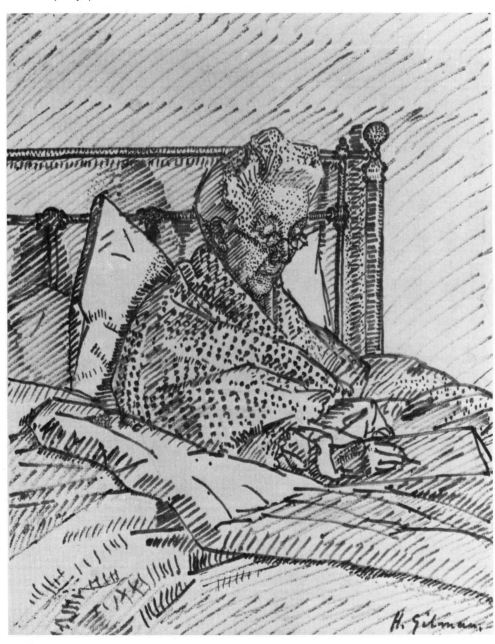

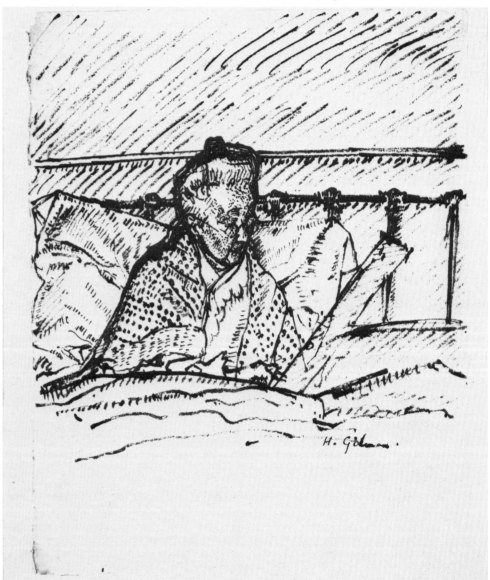

61b Gwen John *Chair study*

62b Gwen John *Women in church*

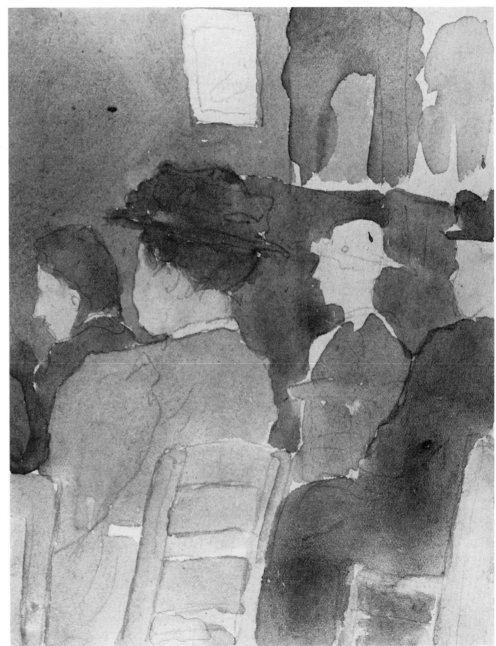

In 1658 Rembrandt made four etchings of
female nudes. Morandi owned an impression of
one of these, the *Reclining Negress*.

Van Gogh writing from Arles in 1880:
*. . . what Rembrandt has alone or almost alone among
painters, that tenderness in the gaze. . .'*

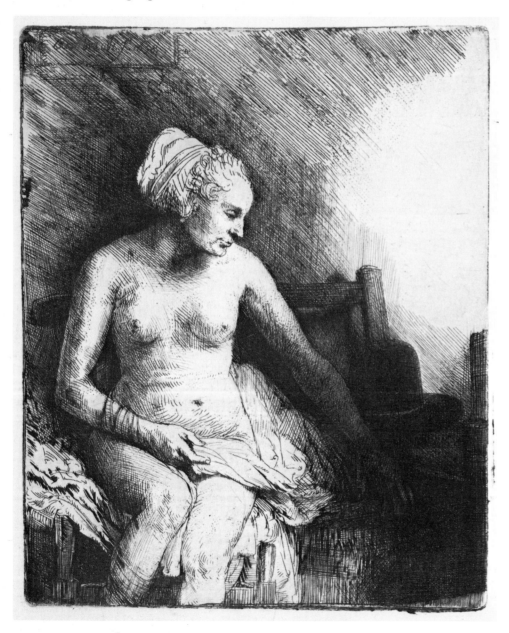

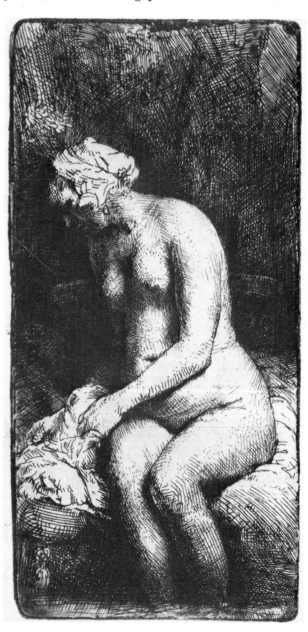

85 Rembrandt *Seated naked woman
with a hat beside her* 1658

86 Rembrandt
Seated naked woman 1658

Catalogue

Works on paper except where otherwise stated.
Measurements are given in centimetres, height
before width

John White Abbott born Exeter 1763, died there
1851.

Abbott studied art under Francis Towne, but was
a practising surgeon, never becoming a professional
artist.

1 *Near the Friar's Walk, Exeter* 1808
pen, ink and watercolour, 19 × 36·2
lent by the Royal Albert Memorial Museum, Exeter

Cornelis Pietersz Bega born Haarlem 1631/32,
died there 1664.

Bega was a grandson of the painter Cornelis van
Haarlem and a pupil of the *genre* painter Adriaen van
Ostade. In 1653 he travelled to Germany and
Switzerland, possibly to Italy. He followed van
Ostade in his choice of subject-matter but his
observation was more particular and his figures more
individually and sympathetically realized. His
refusal to cast his peasants as mere types led to the
neglect of his work in the 19th century. Even Hind,
writing his *History of Engraving and Etching* in 1912
complained that 'Ostade's vigorous line is changed for a
delicate manner of etching which scarcely fits the coarseness
of his subjects'. Thirty-five etchings are known.

2 *Tavern scene* 1662
oil on canvas, 38·4 × 33·6
lent by York City Art Gallery

3 *The blind fiddler* 1663
oil on canvas, 35 × 30
lent by The Visitors of the Ashmolean Museum,
Oxford

4 *A standing peasant woman*
black chalk, 28·4 × 17·6
lent by The Syndics of the Fitzwilliam Museum,
Cambridge

5 *The peasant at a window*
etching, 8·5 × 7·8 (image) 9·3 × 9 (plate) (Dutuit 19)
lent from a private collection

6 *The refused caress*
etching, 7·9 × 6·3 (D24)
lent by The Trustees of the British Museum

7 *The two lovers*
etching, 8·1 × 7·1 (trimmed) (D25)
lent from a private collection

8 *The young hostess*
etching, 17·2 × 15·6 (D26)
lent by the Victoria and Albert Museum

9 *The old hostess*
etching, 18 × 13·6 (D32)
lent by The Trustees of the British Museum

10 *The inn*
etching, 21·9 × 16·9 (trimmed) (D35)
lent by Cheltenham Art Gallery & Museum

John Constable born East Bergholt 1776, died
London 1837.

11 *River scene with vessel: sunset* 1796–9
pencil and wash, 20 × 24·9
lent by the Victoria and Albert Museum

12 *View in Derbyshire* 1801
pencil and wash, 16·9 × 26·1
lent by the Victoria and Albert Museum

13 *Porch of East Bergholt Church from the South-East*
1814–15
pencil, 12·3 × 9·4
lent by The Syndics of the Fitzwilliam Museum,
Cambridge

14 *Portland Island* 1817
pencil and wash, 11·55 × 17·7
lent by the Victoria and Albert Museum

John Sell Cotman born Norwich 1782, died
London 1842.

Numbers 19–22 are preparatory studies for the
etchings which were to be published in 1822 as the
Antiquities of Normandy. Cotman saw this series and
its precursor the *Architectural Antiquities of Norfolk*,
as a way of achieving financial independence.

15 *Lime-kiln at Cromer*
wash, 29·2 × 20·7
lent by the Victoria and Albert Museum

16 *Brignall Banks on the Greta c.* 1805
pencil and watercolour, 18·8 × 28·3
lent by the Leeds City Art Galleries

17 *A ploughed field c.* 1807
watercolour, 22·8 × 35
lent by the Leeds City Art Galleries

18 *On the River Yare c.* 1809
oil on wood, 42·5 × 33·6
lent by the Leeds City Art Galleries
(Sheffield only)

19 *North-west view of tower of Church of Gravelle, near
Havre de Grace* 1818
watercolour and drawing, 22·5 × 17·1
lent by The Trustees of the Tate Gallery

20 *Church at Pavilly near Rouen, looking across the nave* 1818
sepia wash, 27·9 × 23·7
lent by the Victoria and Albert Museum

21 *Church of St Germain Pontandamer – elevation of part of
the nave* 1818–20
pencil and brown wash, 32 × 24·4
lent by the Whitworth Art Gallery,
University of Manchester

22 *Arches of the Cloister of St Georges de Boserville*
1818–21
pencil with brown watercolour wash, 22·2 × 34
lent by The Trustees of the British Museum

Evelyn Dunbar born Reading 1906, died Kent
1960.

From 1938 a member of the Society of Mural
Painters. Commissioned as a war artist in World
War II.

23 *Cabbage picking, Monmouthshire* 1943
oil on canvas, 22·8 × 23
lent by the City of Manchester Art Galleries

Walker Evans born St Louis 1903, died 1975.

Evans took photographs for the Farm Security
Administration between 1935 and 1938, working
mainly in the south-eastern United States but also in
New York City and parts of West Virginia and
Pennsylvania. During this period he collaborated
with James Agee on the book *Let Us Now Praise
Famous Men.*

24 *House near the factory district, New Orleans, Louisiana*
February 1936
(LC–USF342–1297–A)

25 *Church, south-eastern US* 1936
(LC–USF342–8263–A)

26 *Street scene, New York City* Summer 1938
(LC–USF33–6722–M4)

27 *Street scene, New York City* Summer 1938
(LC–USF33–6718–M5)

all purchased by the Arts Council of Great Britain
from the Library of Congress, Washington DC

Harold Gilman born Somerset 1876, died London
1919.

Gilman entered the Slade in 1897. He spent 1904 in
Spain, copying Goya and Velasquez in the Prado. In
1906 he joined Sickert's circle in Fitzroy Street and
in 1911 was a founder member of the Camden Town
Group. Roger Fry's first Post-Impressionist
exhibition in London and a visit to Paris with
Ginner in 1910 broke his former reserve in the use of
colour.

28 *The Nurse* 1908
oil on canvas, 58·4 × 48·3
lent by Mrs Guy Hannen

29 *The Eating house* c. 1912
oil on canvas, 57·2 × 74·9
lent by the Sheffield City Art Galleries

30 *Letter writing (the artist's mother)* c. 1917
reed pen and indian ink, 26·1 × 16·1
lent by The Syndics of the Fitzwilliam Museum,
Cambridge

31 *Artist's mother in bed reading* c. 1917
reed pen and ink, 29·2 × 23·5
lent by the Hatton Gallery, University of Newcastle
upon Tyne

32 *Artist's mother in bed writing* c. 1917
reed pen and grey ink over red chalk, 28·9 × 22·9
lent by The Visitors of the Ashmolean Museum,
Oxford

33 *Artist's mother in bed* c. 1917
reed pen and ink, 38 × 39·5
lent from a private collection
(Sheffield and Cheltenham only)

Charles Ginner born Cannes 1878, died 1952.

Ginner was brought up in France and trained as an
artist in Paris. From the outset he admired van Gogh
and used bright colours. Coming to England in 1910
he became a member of the Fitzroy Street Group
and, later, a founder member of the Camden Town
Group. His essay on Neo-Realism shows him as a
theorist and his background gave Gilman and others

a link with French painting. His method and choice
of subject-matter were established early in his career
and maintained with little change. An official war
artist in World War II.

34 *Flask Walk, rain* 1930s
pen, black ink and watercolour, 34·6 × 23·3
lent by The Visitors of the Ashmolean Museum,
Oxford

35 *New End Square, Hampstead* c. 1930
pen, ink and watercolour, 36 × 27
lent by Hove Museum of Art

36 *Self-portrait* c. 1940
pen with watercolour, 28·6 × 20·2
lent by The Trustees of the National Portrait Gallery

Goussier and others.

Diderot persuaded the bookseller le Breton to enter
upon a new work rather than a translation of
Chamber's *Cyclopedia*. The new work would collect
together all the active writers, all the new ideas and
knowledge of the time. With d'Alembert he
compiled the 28 volumes of the *Encyclopédie, ou
Dictionnaire Raisonné des Sciences, des Arts et des
Métiers*. It was published between 1751 and 1772.
Sections were devoted to graphic descriptions of
each trade, drawn and engraved by several hands.

37a, b *Chapelier* (hat-making) plates I and III
engravings signed by Goussier as draughtsman,
Defehrt and Prevost as engravers, each 35·75 × 22·5

c *Blanchissage des Toiles* (linen-bleaching) plate I
engraving, 35·3 × 22·3

d *Vannier, Outils* (basket-making) plate I
engraving, 35 × 22
lent from private collections

Mary Headlam born Mary Corbett, Norfolk 1874,
died 1959.

Trained at the Slade 1892–96. In 1906 married a civil
servant and lived most of her life in London. Briefly
visited the West Indies in 1936 after her husband's
death. During and after World War II she lived at
Kingswear, Devon. Rarely exhibited.

38 *The Valley of the Chill* 1920s
watercolour and pencil, 24·3 × 35·6

39 *Chanctonbury Ring, near Steyning, Sussex* 1920s
watercolour and pencil, 24 × 32·3

40 *The South Downs, near Steyning, Sussex* 1920s
watercolour and pencil, 24·3 × 35·6

41 *Mandeville, Jamaica* 1936
watercolour and pencil, 29·5 × 23·8

42 *Jamaica* 1936
watercolour and pencil, 32·7 × 26·1

numbers 38–41 lent by the artist's executors, number
42 lent from a private collection

Lewis Hine born Wisconsin 1874, died 1940.

Between 1906 and 1918 Hine, working for the
National Child Labour Committee, made a
comprehensive documentation of the child worker.

43 *Massachusetts Mill* 1913
photograph, 8·9 × 11·4 (contact print)
lent by Lunn Gallery, Washington DC

Utagawa Hiroshige born 1797, died 1858.

Hiroshige and Hokusai are the two most celebrated
Japanese printmakers of the *Ukiyo-e* landscapists.
Ukiyo-e means 'Pictures of the Floating World'.
Prized in the West and enjoying wide popularity in
Japan, they were despised by Japanese connoisseurs
for their concern with the transient, everyday life of
the streets, of actors and courtesans.

44 *Tsuchiyama* from the series *The fifty-three stages of the
Tōkaidō* first published 1834
colour wood-block print, 22·9 × 34·9
The Tōkaidō was the main road between Edo and
Kyoto.
lent by Blackburn Museum and Art Gallery

45 *Aki Province, Festival of Itsukshima* from the series
Famous places in the 60-odd provinces 1855
colour wood-block print, 34 × 22·9 (trimmed)
lent by Blackburn Museum and Art Gallery

46 *Shrine at the side of a lake*
colour wood-block print, 25·4 × 36·8
lent by Blackburn Museum and Art Gallery

Katsushika Hokusai born 1760, died 1849.

Both the following prints are from the series *Thirty-
six views of Fuji, c.* 1823–29.

47 *In the Totomi Mountains*
colour wood-block print, 25·4 × 37·2
lent by the Whitworth Art Gallery, University of
Manchester

48 *Mitsui shop in Suruga Street, Yedo*
colour wood-block print, 37·5 × 25·4
lent by Blackburn Museum and Art Gallery

Wenceslaus Hollar born Prague 1607, died London
1677.

Came to England in 1637 staying at the Earl of
Arundel's palace on the Thames, documenting his
collection through engravings and recording his
travels. Appointed Scenographer Royal in 1665 and
recorded the Great Fire during the blaze. Friend of
Aubrey.

49 Seven etchings from *Theatrum Mulierum*, a study of
women's costume, first published in London 1643.
Some plates appeared only in later expanded
editions.

a *Matrona Argentiniensis* 1642
etching, 10·1 × 6·4

b *Mulier Generosa Viennensis Austrien* 1642
etching, 9·1 × 6·1

c *Mulier Matrisana* 1643
etching, 9·4 × 5·8

d *Civis Londinensis Uxor* 1643
etching, 9·6 × 6·4

e *Ancilla Coloniensis* 1643
etching, 9·4 × 6·1

f *Mulier Basiliensis* 1644
etching, 9·1 × 6·1

g *Matrisana M:* 1648
etching, 9·4 × 5·9

a and d lent by The Trustees of the British Museum,
the others lent from private collections

50 Six views of Islington, 1665, all etchings,
all 9·1 × 12·7

a *By the Waterhouse*

b *Waterhouse by Islington*

c *By Islington*

d *By Islington*

e *On the north side of London*

f *Ye Waterhouse, Islington*

lent by The Trustees of the British Museum

Robert Howlett died 1858.

1 *The Great Eastern* 1857
photograph, albumen print, 28·5 × 36·1
lent by the Institution of Mechanical Engineers

2 *The Great Eastern* 1857
photograph, albumen print, 27·2 × 36·7
lent by the Institution of Mechanical Engineers

Mistress of Ince Castle

Until recently known as the 'Master of Ince Castle', the Mistress still escapes identification. However, a print, not in the Whitworth's collection, is signed 'M. Smith' suggesting that the Mistress might be Mary Smith, daughter of Edward Smith who bought Ince in 1805. The six watercolours listed here are from the Whitworth's collection of thirty-one works.

53 *Portrinkle, Landsend* after 1805
pencil and blue-grey wash, 17·7 × 48
lent by the Whitworth Art Gallery,
University of Manchester (D.268. 1926)

54 *Port Eliot, Cornwall* after 1805
pencil and blue-grey wash pen and ink, 18·4 × 48·3
lent by the Whitworth Art Gallery,
University of Manchester (D.265.1926)

55 *Ince Castle* after 1805
pencil and blue-grey wash, 18 × 48·3
lent by the Whitworth Art Gallery
University of Manchester (D.255.1926)

56 *Ince Castle* after 1805
pencil and blue-grey wash, 18 × 48·3
lent by the Whitworth Art Gallery,
University of Manchester (D.257.1926)

57 *Looking towards Hamoaze from Crafthole* after 1805
pencil and blue-grey wash, 17·7 × 48·8
lent by the Whitworth Art Gallery,
University of Manchester (D.269.1926)

58 *View across Plymouth Sound* after 1805
pencil and blue-grey wash, 18·2 × 48·3
lent by the Whitworth Art Gallery,
University of Manchester (D.272.1926)

Gwen John born Haverfordwest 1876, died Dieppe 1939.

Gwen John, the elder sister of Augustus, went to the Slade in 1895. From 1903 she lived in Paris, moving out to Meudon, where Rodin lived, in 1913. That year she adopted Roman Catholicism. She exhibited rarely and led a reclusive existence – '*my solitude (which sometimes seems a sort of obstinacy)*'. Apart from some still-lifes and a few landscapes her subjects were confined to women and young children. She would paint the same model repeatedly and Cardiff's extensive holdings of late studies include several sets of variations on the same subjects.

59 *Seated girl holding a piece of sewing* 1921–2
oil on canvas, 41 × 33
lent by Aberdeen Art Gallery and Museums

60 *Two nuns and a woman at prayer* c. 1925
pencil and colour wash, 23 × 18
lent by Hove Museum of Art

61 *Chair studies*

a gouache and oil, 16·2 × 12·2

b gouache and oil, 16 × 12·45

c gouache, 14 × 11·4

d gouache, 14 × 11·2

e gouache, 14 × 11·2

lent by the National Museum of Wales
(CXCV 4959–63)

62 *Women in church*

a pencil and gouache, 16·2 × 12·45

b pencil and gouache, 16 × 12·45

c pencil and gouache, 16 × 12·45

lent by the National Museum of Wales
(CXCII 4837–9)

63 *Women in church*
pencil and gouache, 16·2 × 12·45
lent by the National Museum of Wales
(CXCIV 4919)

Leonard McComb born Glasgow 1930.

After two years working in commercial art, McComb went to the Manchester School of Art (1954–6) and studied sculpture and painting (under Coldstream) at the Slade. He then taught, continued to make sculpture, but did not exhibit. In recent years his work has been in drawing rather than sculpture.

64 *Tulips* 1975
watercolour and pencil, 33 × 26·2
lent from a private collection

65 *Oranges* 1975
watercolour and pencil, 25·5 × 28
lent by the artist

66 *Gardens, South London* 1977
watercolour, 79 × 33·75
lent by the artist

Kenneth Martin born Sheffield 1905.

Martin painted his first abstract pictures in the late 1940s. In 1951 he began to make kinetic constructions. '*I was interested in exploring the notion of steps, that is of activity being reduced to simple components and then the product of these explored.*' In recent years he has made paintings and drawings incorporating chance and sometimes using permutations.

67 *Metamorphosis 1c–10c* 1974
ink, each 25·2 × 20
lent by the British Council

68 *Study for Chance, Order, Change 2* (*Ultramarine Blue*) 1976
pencil and ink, 26 × 34·5
owned by the Arts Council

Giorgio Morandi born Bologna 1890, died there 1964.

Cézanne was the first and lasting influence on Morandi's work. Between 1916 and 1918 he joined Carrà and de Chirico in the *pittura metafisica* movement which reacted against the destructive nature of Futurism. For a while he made paintings of invented objects – faceless dummies, whitened bottles – in invented spaces with harsh, clear

shadows. But from 1920 he returned to painting from observation. '*Everything is mystery, ourselves, and all things both simple and humble*'.

69 *Landscape* (*view from the convent at Bologna*) 1921
etching, 7·5 × 12·5 (Vitali 16)
lent from a private collection

70 *Still-life with pine cone and fragment of vase* 1922
etching, 7·5 × 10·7 (Vitali 18)
lent from a private collection

71 *Large still-life with eleven objects in a tondo* 1942
etching, 26·9 × 26·8 (Vitali 110)
lent from a private collection

72 *Still-life, bottle and three objects* 1946
etching, 23·5 diameter (image) (Vitali 104)
lent by the Victoria and Albert Museum

73 *Still-life* 1959
watercolour, 18·5 × 27
lent by Brook Street Gallery

F. Nash (*delin.*) **J. Basire** (*sculpt.*)

74 Four engravings describing the White Tower of the Tower of London published by the Society of Antiquaries of London in Volume IV of *Vetusta Monumenta*, 1815.

a *Plate XLIV, Section of the White Tower from North to South*
engraving, 47·5 × 35 (plate)

b *Plate XLVI, West Side of the room marked A in the Plan of the upper Story. East side of the same room.*
engraving, 31·7 × 48·5

c *Plate XLIX, Transverse Section of the White Tower, from North to South*
engraving, 47·5 × 35

d *Plate L, Longitudinal Section of the Chapel in the White Tower*
engraving, 32·5 × 49·9

all lent from a private collection

Samuel Palmer born London 1805, died Reigate 1881.

75 *Dark trees by a pool*
pen and sepia ink, sepia wash on card, 10·5 × 6·7
lent by The Syndics of the Fitzwilliam Museum, Cambridge

Emma Park born Leeds 1950.

Studied at Chelsea School of Art and the Slade. Works in London.

76 Four sculptures *Untitled December 1978*
wood stained with Cuprinol, each 40·6 × 71·2 × 11
owned by the Arts Council of Great Britain

77 *Small block sculpture* 1979
wood stained with Cuprinol, 30·5 × 30·5 × 12·7
lent by the artist

Eric Ravilious born London 1903, lost while posted with RAF 1942.

Ravilious was trained at Eastbourne School of Art and the Royal College (1922–25). There he was taught in the design school by Paul Nash while spending much of his time in the school of engraving. He took mural decoration as his examination subject. He illustrated a number of books and designed ceramics. Appointed an official war artist in World War II.

78 *The Stork at Hammersmith* 1932
watercolour, 38 × 57
lent by the Towner Art Gallery, Eastbourne

79 *Submarines in dry dock* 1940
watercolour and drawing 43·2 × 57·2
lent by The Trustees of the Tate Gallery

80 *Guardroom* 1940
watercolour, 42·6 × 53·3
lent by The Trustees of the Imperial War Museum

81 *RNAS Sickbay, Dundee* 1941
watercolour, 49 × 54·3
lent by The Trustees of the Imperial War Museum

Rembrandt van Rijn born Leyden 1606, died Amsterdam 1669.

82 *Jan Cornelis 'Silviis' Preacher c.* 1634
etching, 16·7 × 14 (Bartsch 266)
lent by The Visitors of the Ashmolean Museum, Oxford

83 *Woman reading* 1634
etching, 12·3 × 10 (B 345)
lent by The Visitors of the Ashmolean Museum, Oxford

84 *Self-portrait* 1648 (States I, II, III, IV, V)
a–e etchings, 15·7 × 12·8 (B 22)
lent by The Visitors of the Ashmolean Museum, Oxford

85 *Seated naked woman with a hat beside her* (*Woman and bath*) 1658
etching, 15·5 × 13 (B 199)
lent by The Syndics of the Fitzwilliam Museum, Cambridge

86 *Seated naked woman* (*Woman bathing her feet in a brook*) 1658
etching, 16 × 8 (B 200)
lent by The Syndics of the Fitzwilliam Museum, Cambridge

William Roberts born London 1895, died 1980.

Roberts was apprenticed to a poster-designing and advertising firm before attending the Slade, 1910–13. He became an Official War Artist in the last stages of World War I.

87 *Soldiers erecting camouflage at Roclincourt near Arras* 1918
watercolour and ink 41·1 × 34·9
lent by the Victoria and Albert Museum

88 *Brigade headquarters, signallers and linesmen* 1918
oil on canvas, 15·3 × 25·4
lent by The Trustees of the Imperial War Museum

89 *Travelling cradle* 1918 or 1920
watercolour and ink, 59 × 43
lent by Southampton Art Gallery

90 *The Cinema c.* 1920
pen, pencil, sanguine and watercolour (squared in pencil and green ink), 39·5 × 33·2 (image)
lent by the City of Manchester Art Galleries

91 *Love song in a bar* 1923
black chalk, 25·4 × 19·1
lent by the Whitworth Art Gallery, University of Manchester

92 *The Café*
pencil and watercolour, 24·8 × 20
lent by the City of Bristol Museum & Art Gallery

Francis Towne born 1739 probably in Exeter, died in London 1816.

The views of Lake Como and Lake Geneva were made on Towne's one journey abroad. He travelled within Britain but spent much of his time in Exeter where he taught drawing and was commissioned to paint pictures of country houses. He failed eight times to be elected A.R.A.

93 *Lake Como* 1781
pen, ink and wash, 15·6 × 21
lent by the Leeds City Art Galleries

94 *The head of Lake Geneva from Vevay* 1781
pen, ink and wash, 26·3 × 37·9
lent by the Leeds City Art Galleries

95 *Derwentwater from the south* 1786
pen, ink and watercolour, 21·2 × 66·7
lent by the Leeds City Art Galleries